THE ULTIMATE SCENES FOR SCREEN

COLLECTION

A SELF-TAPE PRACTICE BOOK FOR YOUNG ACTORS

BY JOANNE WATKINSON

Salamander Street

First published in 2025 by Salamander Street Ltd. (info@salamanderstreet.com).

Scenes for Screen © Joanne Watkinson, 2025

All rights reserved.

With the purchase of this book comes permission to use the material for showreels with the proviso that the author will be credited.

You may not copy, store, distribute, transmit, reproduce or otherwise make available this publication (or any part of it) in any form, or binding or by any means (print, electronic, digital, optical, mechanical, photocopying, recording or otherwise), without the prior written permission of the publisher. Any person who does any unauthorised act in relation to this publication may be liable to criminal prosecution and civil claims for damages.

ISBN: 9781068696299

10 9 8 7 6 5 4 3 2 1

Further copies of this publication can be purchased from www.salamanderstreet.com

For my students
who have tried and tested my scenes and continue
to inspire me to write more.

INTRODUCTION

I have been an acting teacher for almost 30 years and run screen acting classes alongside my casting agency. These are some of the scenes I have written and used in my classes for the purpose of training my students in producing a good self-tape. Some have been kept short to reflect a self-tape scenario and some a suitable length for showreels (feel free to shorten longer scenes if required)

In many cases the exact age and gender of the characters is flexible. Many are non-gender specific; pronouns and names can be changed as appropriate.

With the purchase of this book comes permission to use the material for showreels with the proviso that the author will be credited.

Socials: Instagram @joannewatkinsonauthor
Facebook Joanne Watkinson playwright
TikTok @joannewatkinsonauthor

Joanne Watkinson
Playwright

CONTENTS

The bracketed information indicates the approximate age range of the characters in the scenes. This is flexible in some cases, and open to interpretation. However, parents, guardians and teachers of younger children are advised to check scenes for suitable subject matter.

Points to consider when putting together a self-tape......	5
The Note (pre-teen or teen/adult).....................................	9
Ghost (Pre-teen/teen)...	11
Doing Time (Pre-teen or early teen/adult).....................	14
Believe Me (Pre-teens or teens)	17
Caught on Camera (Pre-teens or teens).........................	19
Deathly Dilemma (Teens)..	21
Leaving (Pre-teens or pre-teen/teen).............................	25
Fake Friends (Teens)...	27
Arson (Teens)..	32
Cheat (Pre-teens or teens)...	36
First Date (Teens)...	40
First Day (Teens)..	43
Missing (Teens)..	50
Not of This World (Pre-teen or teen/adult)...................	54
Outside the Courtroom (Teens)......................................	58
Teens (Teens)...	62
The Hunt (Pre-teen or teen/adult)..................................	64

The Lie (Older pre-teen or teens)...............................	69
The Lifeboat (Pre-teen or teen)...................................	70
The Plan (Teens)..	74
Trapped (Teens)...	76
Unwanted Guest (Pre-teens or teens/adult)................	79
Vayda (Teen/adult)..	82
The Other Half of Me (Teens)...................................	88
Cyber Consequence (Teens).......................................	91
A Birthday Surprise (Pre-teens or teens)...................	95
The Break-up (Pre-teen/teen)......................................	97
Santa Can Only be Red (Pre-teen/adult)....................	100
The Last Goodbye (Pre-teen/adult)............................	103
The Woods (Pre-teen/teen)...	106
Hiding (Pre-teens or pre-teen/teen)............................	109
Red Flag (Teens)..	114
Invasion (Pre-teens, Teens or adults).........................	119
The Projector (Pre-teen/teen).....................................	123
Spooked (Pre-teen/teen)..	128

POINTS TO CONSIDER WHEN PUTTING TOGETHER A SELF-TAPE

When your agent is sent a request for you to tape they will send you the 'sides', this is the script which you need to learn off book.

Read the brief carefully and do any research that may be available regarding character and plot. It can even be useful to explore the director's previous work to see if they have a particular style.

Be aware of the genre. For example: A TV drama aimed at an adult audience may require a greater depth of naturalism than a children's programme or commercial.

Try the scene in different ways, some briefs give the opportunity to submit a couple of takes. Take advantage of this.

'Actioning' the scene would be a useful exercise. To do this apply an action verb to each line. This will help develop the scene. Ask yourself 'What is my character's objective?'

Film landscape on your phone and use a tripod to keep the camera steady.

Film your scene in a quiet space against a plain background.

Make sure you have good lighting and avoid shadows and silhouette. It is worth investing in a ring or photography light.

Make sure the person reading in the other lines isn't louder than you. They don't need to read the stage directions aloud.

Film head and shoulders/mid-chest unless otherwise stated. Fill the frame so the casting director can see your expressions.

Don't look directly into the camera unless the brief requests this. Your eye line needs to be slightly off centre, position your reader next to the camera so you can look at them.

You will sometimes be asked to do an IDENT or SLATE. This is a short introduction which includes basic information such as name, height, where you are based and your agency name. This should be delivered into the camera and positioned as a head and shoulders/mid-chest shot unless otherwise stated. First impressions matter.

Label your video in files as requested by the casting agency. Your agent may do this for you.

There is no need to do a fancy intro to your self-tape, for example they don't need to see a headshot with your name splashed across it for several seconds before your scene. Their time is precious! They just want to see you act.

If you are taping without the help of another person, be aware, no one wants to see you walking to your position after you have pressed record or returning to your camera to stop the recording at the end. Edit the video down before sending.

My biggest tip to young performers is to remember to react. It isn't just about learning lines or simply delivering a great line, if you don't react to the other character or characters, you're not doing your job.

It's a fast-paced industry, with quick turnarounds so be prepared for learning lines and submitting a tape in anything from a day to a few days, which is not uncommon and for that last-minute trip for an in-person audition, this is more commonly for a recall. At this stage you know you've caught their eye and have something they're looking for.

I wish you all the best with your acting journey. It is a competitive industry, so try not to let rejections knock you back. Keep working hard at your craft and one day your talents will hopefully be recognised by the right person. If you're lucky enough to get a self-tape request or in-person audition do the best job you can and once completed forget about it. Sometimes you will get a polite 'we won't be taking this further' and other times your agent won't hear anything back. The day you get a booking will make the journey worthwhile so just keep at it!

I hope you have fun trying out these scenes. You can share them with parental permission by tagging @eta.management on Instagram, ETA Management on Facebook or my other pages.

With the purchase of my books, you get permission to use for showreels and audition material.

THE NOTE

INT. BEDROOM - DAY

The CHILD enters and is taken aback to see her PARENT shutting her cupboard drawer.

CHILD

What are you doing going through my things?

PARENT

I wasn't. I was putting your clothes away. I found this.

CHILD

I don't want to talk about it.

PARENT

Well, I do. We can't ignore this.

CHILD

You always think you have the right answer. You can't fix this.

PARENT

Who wrote this?

CHILD

No one.

PARENT

It didn't write itself.

CHILD

No-one you know.

PARENT

I'm here for you. You know that don't you?

CHILD

You wouldn't understand.

PARENT

You might be surprised.

CHILD

I've told you I don't want to talk about it. Don't tell Dad.

PARENT

He would understand.

CHILD

No, he wouldn't, please don't say anything.

PARENT

Okay but you need to talk to me. Who wrote this?

FADE OUT.

GHOST

INT. KITCHEN - DAY

CHILD sits at the kitchen table drawing a picture. Older sibling enters.

SIBLING

Hey, what are you doing?

CHILD

A picture.

SIBLING

That's good. Is that you?

CHILD

Yes.

SIBLING

Who's this?

CHILD

No one.

SIBLING

They look a bit scary. Why are they sat on your bed?

CHILD

That's where she sits when she visits me.

SIBLING

Visits you?

CHILD

Yes, at night.

SIBLING

Like a ghost you mean?

CHILD

I know what you're going to say. I've got a vivid imagination, no one at school believes me either.

SIBLING

Do you want to sleep in my room tonight?

CHILD puts down her crayon and looks at her SIBLING.

CHILD

No thanks, she's not scary, and anyway she visits you too. You just can't see her.

SIBLING

I think you should tell Mum.

CHILD

I can't.

SIBLING

Why?

CHILD

She'll get sad.

SIBLING

Why would it make her sad?

CHILD

Because it's Gran.

						FADE OUT.

DOING TIME

INT. UNKEMPT LIVING ROOM - DAY

REGAN is in the doorway unsure whether to enter the living room.

UNCLE

Can I get you a drink?

REGAN shakes head.

UNCLE

What about a sandwich?

REGAN looks at his UNCLE with sadness in his eyes.

REGAN

How long do I have to stay here?

UNCLE

Just while your dad's away.

REGAN

How long is that?

UNCLE

Why don't you come in and sit down?

REGAN slowly and reluctantly walks to the sofa.

UNCLE

Sit.

REGAN takes a seat.

REGAN

How long?

UNCLE

A while, he's working abroad.

REGAN

I'm not stupid.

UNCLE

I know you're not.

REGAN

So why are you lying?

UNCLE

I'll get you that sandwich.

REGAN

He's in prison, isn't he?

UNCLE nods and sits by REGAN.

UNCLE

Yeah.

REGAN

What did he do? And don't lie.

UNCLE

He took something that didn't belong to him.

REGAN

Did he give it back?

UNCLE

He can't.

REGAN

He took that man's life, didn't he? The one on the tele. Don't try and lie to me, the kids at school are talking about it.

UNCLE

It was an accident.

REGAN

You're a liar.

FADE OUT.

BELIEVE ME

EXT. PARK - DAY

ALEX is sitting on a bench when JO arrives.

ALEX

I thought you weren't coming.

JO

I almost didn't.

ALEX

Did Mum see you leave?

JO

I said I was meeting Tommy.

ALEX

You need to come home.

JO

No chance.

ALEX

Come on, Jo, Mum's missing you.

JO

Auntie Louise said I could stay as long as I want. As long as he's there.

ALEX

I think they've had an argument; he didn't come home last night.

JO

Home. It's not his home, Alex. She chose him, she didn't believe me.

ALEX

Just talk to her.

JO

There's no point, she chose him.

FADE OUT.

CAUGHT ON CAMERA

EXT. THE WOODS - NIGHT

JP is dragging JUDE by the arm, pushing branches out of the way. They come to a sudden stop.

JP

Did you hear that?

JUDE

I was trying to shut it out.

JP

I heard it!

JUDE

I don't like it here.

JP

Get a grip.

JUDE

Why did you make us come here?

JP

I told you, for the adventure.

JUDE

Couldn't we have an adventure in a less scary location?

JP

Don't be a baby. If we get it on video, we will be rich.

JUDE

How exactly?

JP

Well, the news would want it for a start.

JUDE

No they wouldn't.

JP

Why not?

JUDE

Because they would say it's fake, everyone would.

JP

They can tell these days if it's fake and I'm telling you I've seen it before.

Now be brave and follow me.

FADE OUT.

DEATHLY DILEMMA

INT. BEDROOM - DAY

BEA

What have you done?

DAVID

Me?

BEA

You gave her it?

DAVID

She wanted it. You were encouraging her.

BEA

She wanted to.

DAVID

That's what I said. I'm not taking the blame.

BEA

We need an ambulance.

DAVID

Bea, she's dead.

BEA

No, she's not, she can't be. Anna wake up, wake up. Don't just stand there. Wake up, Anna.

DAVID

What do you want me to do?

BEA

She's your girlfriend. Don't you care?

DAVID

Of course.

BEA

Do something.

DAVID

I need to go; I'm not going to prison.

BEA

You're so flaming selfish. You gave her the pill, I'll tell them. You killed her! You!

DAVID

Calm down will you, someone will hear you.

BEA

Don't tell me to calm down, don't ever tell me to calm down.

DAVID

You'll be blamed too, you encouraged her.

BEA

Anna, wake up. Please just wake up.

DAVID

Her mum will be home soon. Let's just put her in her bed and leave.

BEA

I'm not leaving her.

DAVID

You have to. What will your mum say? You'll get arrested.

BEA

I'm not leaving her. You made her hold this party; her mum doesn't even know. What will she say when she finds out her daughter's dead. You don't even care.

DAVID

I'm going.

BEA

Go on then, just go! You're pathetic!

DAVID goes to leave.

DAVID

She's back. Her mum is back.

DAVID goes to the window.

BEA

Seriously! You're going through the window? We're on the third floor.

DAVID

I'm not staying.

BEA

You're a coward. Go on then, go! What are you going to do? Slide down the drainpipe like in the films. I hope you fall. Anna would hate you for this.

DAVID stops.

BEA

I know you're scared. I am too, but we have to face this. For Anna.

FADE OUT.

LEAVING

INT. BEDROOM - DAY

 ASH

I don't want to go, Charlie.

 CHARLIE

Mum said the house is right by the park.

 ASH

I'll have no one to go to the park with, my friends are here.

 CHARLIE

You'll make new friends.

 ASH

I don't want new ones; I like the ones I've got. I like it here.

 CHARLIE

We can visit in the school holidays.

 ASH

Please persuade her to stay. I can't go. I can't. My friends will forget me. I like it here, I like our house, my school...

CHARLIE

You've never liked school.

ASH

I like my friends; I like my life the way it is. I'm not going she can't make me. She can't.

CHARLIE

Come here.

CHARLIE embraces ASH.

 FADE OUT.

FAKE FRIENDS

INT. BEDROOM - DAY

TERRI

I told you, didn't I?

FLO

Oh, don't get on your high horse, Terri.

TERRI

You lied.

FLO

You're so conceited.

TERRI

I'm so right, again.

FLO

I'm not sure why I put up with you.

TERRI

Because I'm popular and hanging out with me prevents you from a life of eternal unpopularity.

FLO

Yeah, that's right, Terri, my life would be over without you.

TERRI

No need for sarcasm, Flo. You know it's true.

FLO

I hang out with you because I fancy your brother. That's it.

TERRI

Knew I was right!

FLO

Yes, you're right, for once. So not exactly all about you is it, Terri?

TERRI

So, you're using me to get to my brother. I've never been used before, so this is what it feels like.

FLO

Welcome to reality.

TERRI

No offence ,Flo, but you can go now, you're no great loss to me. I've got loads of friends.

FLO

Yeah, you're surrounded by them.

TERRI

I can be friends with whoever I want, they're all just intimidated by my greatness.

FLO

Your what? You need to get a grip, my friend.

TERRI

I'm not your friend.

FLO

No, we've established that. I'll go then, shall I?

TERRI

Yeah go!

FLO

Fine.

TERRI

Fine.

FLO

But before I do, can I just say hi to your brother

TERRI

No, you can't.

 FLO

Fine.

 TERRI

Fine.

 FLO

I'll go then.

 TERRI

Go.

 FLO

Okay, okay, I'm going. Bye then.

 TERRI

Bye. Don't come back.

 FLO

Wasn't planning on.

 TERRI

Fine.

 FLO

Fine.

 TERRI

You're stalling. My brother's not in you know.

 FLO

Fine. Goodbye!

TOM walks up the garden path.

FLO

Oh, hi Tom, I was just…

TERRI

She was just leaving.

　　　　　　　　　　　　　　　　FADE OUT.

ARSON

EXT. A BENCH ON THE HILL - EVENING

 LEA

Hey.

 THORA

Hi.

 LEA

What are you doing up here?

 THORA

Watching.

 LEA

Crazy, isn't it?

 THORA

Yeah.

 LEA

It's on the news. They reckon it's arson.

 THORA

How do they know?

 LEA

Witnesses saw some kids messing about.

THORA

That doesn't mean they did it.

LEA

Okay.

THORA

Yeah, well it doesn't, does it?

LEA gets out her phone and begins to scroll.

LEA

Are you OK? You don't seem yourself.

THORA

I just want to be alone okay!

LEA

Fine. See ya.

LEA gets up to leave.

LEA

Oh, my God ,they've found a body.

THORA looks visibly shaken.

LEA

Thora, are you alright?

LEA sits down next to THORA again.

LEA

You're shaking.

THORA

He made me.

LEA

What?

THORA

I didn't start it.

LEA

The fire?

THORA

It was Thomas Levy, he made me go with him. He said if I tell anyone he will put the blame on me.

THORA begins to cry. LEA gets out her phone and starts dialling.

THORA

What are you doing?

LEA

You need to tell them.

THORA

I can't my mum will be so…

LEA

Police please?

THORA

Don't.

LEA hands THORA the phone.

FADE OUT.

CHEAT

INT. BOARDING SCHOOL DORMITORY - EVENING

JULES

I'll pay you.

WILL

I don't want your money.

JULES

Please, Will.

WILL

I can't.

JULES

You mean you won't.

WILL

You're right I won't. It's cheating.

JULES

It's assisting.

WILL

Assisting you to pass an assignment you haven't even studied for.

JULES

I tried. I did. It's just so hard.

WILL

Hard work you mean.

JULES

I've been busy.

WILL

So have I, Jules, but I still made time. What makes you think I have time to write another essay? The deadline is tomorrow.

JULES

If I fail this, then I fail the whole course. Please. If you care about me, you'll do it.

WILL

Emotional blackmail now, Jules? That's a low blow even for you. If we get found out, I'll fail too.

JULES

We won't. I'll even stay up with you all night to keep you company.

WILL

Cos that's not distracting at all.

JULES

Fine. I'll stay out of your way and give you 20 quid.

WILL

If I get kicked out of school for this my parents will disown me. Do you know how much fees are for this place?

JULES

Exactly. I can't fail and let my parents down. If I get kicked out, you'll never see me again. What would your life be like without your best mate?

WILL

Quiet.

JULES

Charming.

WILL

I'll stay up.

JULES

Thanks, Will. You're the best.

WILL

I'll stay up and help you.

JULES

Wait. What?

WILL

But I'm not doing it for you.

JULES

Fine. But I want at least a B.

WILL

B it is. Now grab that textbook.

JULES

I'm bored already.

WILL

It's going to be a long night.

FADE OUT.

FIRST DATE

EXT. PARK BENCH - DAY

FRANKIE is nervously sitting on a park bench. DALE approaches.

 FRANKIE

So?

 DALE

So?

 FRANKIE

You came.

 DALE

I did.

 FRANKIE

I'm glad you did.

 DALE

Thanks.

 FRANKIE

So?

 DALE

So?

 FRANKIE

What do you want to do?

DALE

You invited me.

FRANKIE

Yeah, I guess.

DALE

So, you haven't actually got a plan?

FRANKIE

Erm.

(BEAT)

FRANKIE

I haven't you know?

DALE

No, I don't.

FRANKIE

I haven't you know, been on a date before.

DALE

Oh.

(Awkward silence.)

FRANKIE

So.

DALE

So?

 FRANKIE

 Nothing.

(BEAT)

 DALE

 I haven't been on a date before
 either.

Silence. FRANKIE shuffles closer to DALE who
looks at FRANKIE and smiles.

 FADE OUT.

FIRST DAY

INT. CANTEEN - DAY

ANNA approaches a table where popular girl LILY is sitting eating her lunch. She acknowledges an empty seat.

ANNA

Hi, do you mind if I sit here?

LILY

You're the new kid.

ANNA

Yep. That's me, am I that obvious?

LILY

You look a bit lost. Sit.

ANNA

Thanks.

LILY

Where did you move from?

ANNA

I lived down south, in the outskirts of London.

LILY

That must've been so cool.

ANNA

Nothing special.

LILY

Well, it's pretty boring here, so don't get too excited.

JACK

Hey! Who do we have here?

LILY

Get lost, Jack.

JACK

Charming. I've just come to introduce myself to your new friend.

LILY

She's not interested.

ANNA reaches out to shake his hand.

ANNA

Hi, I'm Anna.

JACK

Very formal. See she wants to know me, Lily, you can't have her all to yourself.

LILY

Great.

LILY addresses ANNA under her breath.

LILY

What did you do that for?

ANNA

Sorry. He's kind of cute.

LILY

He's an idiot.

JACK

What was that?

LILY

Nothing. Just do one, Jack.

JACK

Pleased to meet you, Anna. I'm having a party this weekend you're invited. (To LILY) You're not.

ANNA

Erm, thanks, I'll let you know.

JACK

You do that. I'll add you on Snap.

ANNA

Oh, okay.

JACK

See you Saturday. Lily, I hope not to see you any time soon.

JACK exits.

LILY

I hate him!

ANNA

What's the story with you two?

LILY

It's long and boring.

ANNA

It's okay if you don't want to share.

LILY

We used to go out, until he got his claws into Josie Stevens. He's bad news. Speak of the devil.

JOSIE

What are you doing talking to Jack?

LILY

If you must know, he was talking to us.

JOSIE

I've told you, back off, Lily. He's not interested anymore.

LILY

He doesn't seem interested in you either.

JOSIE

Shut your mouth, Lily, you don't know anything.

LILY

I know he's just been chatting Anna up.

JOSIE

Anna who?

ANNA

Okay it's time for me to go. I don't want to be late to class.

JOSIE

Is it you? Are you Anna? First day here and you go stealing other people's boyfriends. There's a name for people like you.

LILY

Get lost, Josie. She didn't do anything.

ANNA

Sorry I'm going to be late.

JOSIE

Sorry I'm going to be late. Pathetic.

ANNA leaves with haste and bumps straight into JACK, she drops her bag.

ANNA

Sorry. I, I'm sorry.

JACK

Wait let me.

JACK picks up her bag.

JACK

Don't listen to Josie, I had one date with her and now she's obsessed.

ANNA

I just want to get to class.

JACK

Sure, I'll Walk you there. Where do you need to be?

ANNA

Really, I'll be fine.

JOSIE shouts from across the canteen.

JOSIE

You know what you are, don't you, new girl?

JACK

Get a grip, Josie. I'm not your boyfriend, or yours for that matter, Lily.

LILY

Thank God.

ANNA

Well, it's been nice meeting you all, I'll be getting to class now.

ANNA exits.

ANNA

Jeez.

FADE OUT.

MISSING

INT. SCHOOL YARD - DAY

 JAY

It was you, wasn't it?

 DENNI

What?

 JAY

You were the last person to see her.

No response, DENNI is staring through the window.

 JAY

Denni. Did you meet her?

 DENNI

She seemed fine.

 JAY

No one will blame you.

 DENNI

She seemed fine, just her usual self.

 JAY

You need to tell someone.

DENNI

I'm telling you, aren't I?

JAY

The police I mean.

DENNI

What difference will it make?

JAY

It might help find her.

DENNI

They'll think the worst. Like I had something to do with her disappearing. Like you.

(BEAT)

DENNI

You think I did it, don't you?

JAY

No.

DENNI

Yeah, you do, I can see it in your face. You think I've done something to her don't you?

JAY

I don't think anything.

DENNI

Stop lying. You think I hurt her; you think I wanted her to disappear.

JAY

Did you?

DENNI

For God's sake. Just go.

JAY

You need to tell the police.

DENNI

And if I don't?

(BEAT)

DENNI

Thought so. You'll tell them for me.

JAY

It's better coming from you.

DENNI

Maybe she doesn't want to be found.

JAY

Or you don't want her to be found.

DENNI

You need to leave. Why wouldn't I want my own sister to be found?

 JAY

We both know why.

 FADE OUT.

NOT OF THIS WORLD

INT. GOVERNMENT INTERROGATION ROOM - DAY.

ASHA is sitting at a large table in a darkly lit room with no windows.

AGENT JONES is standing opposite.

ASHA

How long are you going to keep me here?

AGENT JONES

As long as it takes. When did you arrive?

ASHA

About an hour ago, but you know that. You brought me here.

AGENT JONES

I think you know what I mean.

ASHA

I told you.

AGENT JONES

You told me you were human.

ASHA

Exactly. I've been here my whole life.

AGENT JONES

Reports say you burnt the officer, but you had no heat source. You burnt him with your touch.

ASHA

People have vivid imaginations.

AGENT JONES

Do you think you're dangerous? Am I in danger by talking to you?

ASHA

You have a vivid imagination.

AGENT JONES

I know that your blood type is nothing I've seen before. Your DNA is not of this world.

ASHA

I'm unique.

AGENT JONES

You're dangerous.

ASHA

I'm a child.

AGENT JONES

Are you? You've hurt people.

ASHA

It wasn't intentional.

AGENT JONES

You can't control it?

ASHA

It? It! What is it, Agent Jones?

AGENT JONES

You know they'll keep you here if you don't cooperate. They'll do more tests.

ASHA

Am I supposed to be afraid? Well, I'm not. But maybe you should be.

AGENT JONES

Are there others?

ASHA

Others?

AGENT JONES

Like you. Are there others like you walking amongst us?

ASHA Laughs.

ASHA

You make it sound like a Hollywood movie.

AGENT JONES

Asha, if that's really your name, you need to tell me the truth. They won't let you go until they know everything about you.

ASHA

Well, they don't know what they're getting involved with.

AGENT JONES

Then help me understand.

ASHA

This interview is over.

AGENT JONES

Then you give me no choice.

ASHA

No, Agent Jones, you've given me no choice.

A fire starts behind AGENT JONES. The door appears to lock itself as AGENT JONES tries to leave. ASHA smirks.

 FADE OUT.

OUTSIDE THE COURTROOM

INT. CORRIDOR OF THE COURTHOUSE - DAY

SAM

You said you'd tell the truth in there.

TOM

You said you weren't coming.

SAM

Well, I needed to see it for myself. You should've told the truth.

TOM

I told you I'd protect you.

SAM

I don't need protecting, Tom.

TOM

If I'd told the truth the police would've been knocking at your door, then what?

SAM

You could end up going to a Young Offenders.

TOM

My solicitor is good. She was good, wasn't she?

SAM

You need to tell the truth. You can't take the blame for me.

EARLIER THAT YEAR

EXT. DERELICT PROPERTY - NIGHT

SAM

She's not moving. Tommy, she's not moving.

TOM

Stay calm.

SAM

Ring an ambulance. Quick ring an ambulance.

SAM goes to phone 999, Tommy stops her.

TOM

Don't.

SAM

What did you do that for?

TOM

Sammy, she's dead.

SAM

Oh, my God, oh my God. No! No, please no! Wake up, Ava, please wake up.

TOM

She's gone. We have to go.

SAM

Go where?

TOM

We have to leave her, Sam.

SAM

No, we can't. I'm not leaving her.

TOM

Do you want to get arrested?

SAM

It was an accident.

TOM

Was it?

SAM

What are you saying?

TOM

You pushed her.

SAM

I didn't mean for this. Oh my God, Ava, wake up, wake up! You've got to wake up. I'm sorry, I didn't mean to, I didn't…

 TOM

Sammy, we need to go. Let's go.

 FADE OUT.

TEENS

EXT. STREET - DAY

MAX

Did you get some?

BAILEY

My Dad's going to go ape.

MAX

He won't notice he's always hammered. What did you get?

BAILEY

Whiskey.

MAX

Whiskey? That's for old blokes.

BAILEY

My Dad is an old bloke.

MAX

Give it here.

MAX takes a swig.

MAX

That's gross it tastes like antiseptic.

BAILEY

Well, it's all he had.

MAX

We're going to look like little kids arriving with this.

BAILEY

I don't want to go anyway.

MAX

Course you do. It's a party and let's face it we don't get invited to many.

BAILEY

Exactly, why would they want us there. Makes no sense, they don't even like us.

MAX

Stop whining, here have a swig of this.

FADE OUT.

THE HUNT

EXT. DESERTED ROAD - Night. surrounded by woods.

TONI is walking along the roadside. A MAN pulls up in his van.

> **MAN**
>
> Hey, you look a little lost out here.

> **TONI**
>
> I'm fine.

> **MAN**
>
> Do you need help? It's dangerous out here at night.

> **TONI**
>
> I'm not getting in.

> **MAN**
>
> I didn't ask you to.

> **TONI**
>
> Good. Well now we've established that, you can go.

> **MAN**
>
> What happened to you? Where are your shoes?

TONI

I don't talk to strangers.

MAN

Where are your parents?

TONI

You ask a lot of questions.

MAN

Were you in an accident? Are your parents hurt?

TONI

They're coming to get me. They'll be coming round that corner any second.

MAN

Any second, right?

TONI

And my Dad's six foot and a black belt.

MAN

He sounds like a scary guy.

TONI

The scariest.

MAN

I'd better drive off then and leave you. You know you shouldn't be out here alone.

 TONI

 And you shouldn't be talking to kids
 you don't know.

 MAN

 You're a smart ass. Did your Dad
 ever tell you that?

 TONI

 And you're creepy. Did yours ever
 tell you?

MAN laughs.

 MAN

 You hungry? There's a roadside I
 just a bit further down.

 TONI

 Are you trying to get me in your
 car?

They pause and stare at each other. TONI
is deciding which way to run.

 MAN

 Come on. You look like you need a
 ride.

 TONI

 And you look like you're a serial
 killer.

TONI runs into the woods away from the road. MAN makes chase. She slips and falls, MAN grabs her round the neck.

MAN

There are too many smart asses in this world.

TONI

Let go of me.

MAN

I was just trying to help. You ungrateful little…

The MAN gets whacked around the head with a branch. A six-foot figure stands over them.

TONI

Dad!

DAD

There are too many weirdos in this world. Nice work Toni that's one more down.

TONI

You took your time.

DAD

I had to wait till he made chase.

TONI

I guess. But tomorrow night can I wear shoes? My feet are killing.

DAD picks her up cradle style and carries her back to the roadside.

DAD

Sure. MacDonalds?

TONI

Yeah. I'm starving.

FADE OUT.

THE LIE

INT. SCHOOL BATHROOM - DAY

MATTIE

Are you serious?

SYD

Are you seriously asking me to lie for you?

MATTIE

Are you seriously thinking of grassing me up?

SYD

It's always so simple with you, isn't it?

MATTIE

You think this is simple? Simple! Nothing you have ever got me involved in turned out to be simple.

Come on, Mattie. We go back a long way.

MATTIE

You crossed a line.

FADE OUT.

THE LIFEBOAT

EXT. AT SEA - NIGHT

SEAN

You think they're coming for us?

POL

Of course they are.

SEAN

I'm cold.

POL

Come here.

SEAN

I can't stop shivering.

POL

Stay strong, someone will find us.

SEAN

What about Dad, Pol? Will he make it.

POL

Of course, he's so strong.

SEAN

He's a good swimmer, isn't he?

POL

The best.

SEAN

The best.

POL

When we get home, I'm going to take you to that new sweet shop up near Grandma's house. Sean, did you hear me? Sean don't fall asleep. You need to stay awake.

SEAN

I'm so tired.

POL

But we need to look out for the lifeboat.

SEAN

You look for it, Pol, I'm just going to rest my eyes.

POL

Please, Sean, don't fall asleep.

SEAN

Do you think everyone is dead?

POL

Stop thinking like that. We must stay positive.

SEAN

I'm so thirsty.

POL

It won't be long now.

SEAN

But how would they even know our ship sank?

POL

They know.

SEAN

I can't handle the cold, Pol. It hurts and I'm tired.

POL

Look at the sky, the moon is so big tonight. Shining bright, so it will be easier for them to see us. The stars are so pretty.

SEAN

Pretty.

POL

Let's look for a shooting star.

They both lay quietly together looking at the stars, eventually they fall asleep. A bell from the lifeboat eventually wakes POL, she is barely able to speak.

POL

Here. We are here. Sean wake up, they've found us. Sean, Sean, Seanie wake up, we're going home. Sean, Seanie, please wake up. It's time to go. wake up please wake up.

FADE OUT.

THE PLAN

INT. A SHOP - NIGHT

COLE

Well, I think that went to plan.

SKYE

Really?

COLE

Yes, it seems to have worked.

SKYE

Then why are we stuck in here?

COLE

Ah, well you see I only planned the first bit.

SKYE

Right, so the crucial escape route bit you just thought we'd wing?

COLE

I didn't realise the building would go into lock down when the alarm went off.

SKYE

Okay, so you thought we would rob the place then just stroll out the front door? I only did this because

you said it was fool-proof! And I needed the money.

COLE

Just a small lapse in judgement. The next one will go better, we can plan it together.

SKYE

Next one!? The only place we will be planning to escape from is prison!

COLE

Yeah, well that can be done too, I've seen it on the TV.

SKYE

I give up! Can't believe I didn't realise your level of stupidity, before I pulled a pair of your mothers' tights over my head. Did you get that idea from TV too?

COLE

Crime Investigation Squad, Season 1 Episode 27.

SKYE

Think you need to start watching the Prison Break box set!

Sirens can be heard.

SKYE

Too late!

FADE OUT.

TRAPPED

INT. BASEMENT - DAY

BILLIE is in a dimly lit basement and is blindfolded.

BILLIE

Please don't hurt me.

The noise of a door slamming can be heard. BILLIE is feeling around the space, panicked.

BROOK

He's gone.

BILLIE

Who's there?

BROOK

You can take your blindfold off. He's gone.

BILLIE slowly removes the blindfold.

BROOK

He won't be back for hours. I'm Brook.

BILLIE

Where am I?

BROOK

I don't know. It's a kind of basement, I think. I hear him moving around above sometimes. What's your name?

BILLIE

Billie.

BROOK

You'll get used to it, Billie. Just don't make him mad.

BILLIE

I want to get out.

BROOK

Stay calm, he'll hear you.

BILLIE

How long have you been here?

BROOK

I think it's been a year. I don't know. I used to try and count the days, but it got too difficult, there's no sense of time here.

BILLIE

How are you so calm?

BROOK

The sooner you accept the situation the less you can be hurt by it.

BILLIE

We have to get out.

BROOK

I've tried.

BILLIE

My parents will be looking for me.

BROOK

Just do what he says and don't make him angry.

BILLIE

I want to go home.

BROOK

You are.

FADE OUT.

UNWANTED GUEST

INT. BEDROOM - NIGHT

HELENA is asleep in her bed. Her bedroom has an old-fashioned feel to it. It is silent. She begins to become restless in her sleep. We see her breathing become heavier, suddenly we see her breath. It's has become cold. She wakes with a start and sits bolt upright. She stares, frightened. It's not the first time this has happened.

HELENA

Faye. Faye.

The camera reveals a second child in the room who is sleeping soundly in a matching bed.

HELENA

Faye. It's happening again. Wake up.

FAYE

Helena. Go to sleep.

HELENA

I feel it. The cold. I feel it Faye.

A scratching sound is heard. FAYE sits upright. Then moves quickly to HELENA's bed.

FAYE

I don't like this. Mum!

The scratching sound gets louder, drowning her voice.

HELENA

Stay quiet. You're making it angry.

A picture falls from the wall smashing on the floor. FAYE goes to scream but HELENA covers her mouth.

HELENA

Don't make a sound.

FAYE

I don't like this. We need to get out.

Suddenly their duvet is pulled from their bed. They scream instinctively. The door opens then slams shut. Mum appears at the door.

MUM

What's all the noise?

The following lines are delivered simultaneously:

HELENA

It happened again, the cold. It woke me and Faye jumped into bed then it took our covers, and the picture

fell. The door slammed all on its own. I hate it here.

FAYE

There's a ghost, you have to believe us. It took Helena's duvet, and the picture flew off the wall. Look Helena's duvet, it's on the floor. It did that. Please believe us this time.

MUM

Woah! One at a time.

HELENA

The ghost is back.

FADE OUT.

VAYDA

EXT. PARK BENCH - DAY

KITTY is a foundling taken in by a family when she was a baby. She is being followed by a stranger who has been watching her all her life. This scene takes place on a bench Kitty sits with the stranger; she knows they've been watching her.

KITTY

Who am I? You've been watching me.

VANYA

Your name is Vayda.

KITTY

Are you my real father?

VANYA

No.

KITTY

Who are you?

VAYDA

I've been sent to watch you.

KITTY

That's creepy.

VANYA

To watch over you.

KITTY

Still creepy.

VANYA

To take care of you.

KITTY

Better, but still creepy.

VANYA

You feel different to the other kids, don't you?

KITTY

I don't fit in. I'm adopted but you probably already know being that you have a creepy obsession with me.

VANYA

If you think I'm so creepy why are you still sat here?

KITTY

I feel like I know you. Do I?

VANYA

No, but I know your mother.

KITTY

Where is she? Does she want to meet me? Do you know my father?

VANYA

Slow down. One thing at a time, Vayda.

KITTY

My name's Kitty.

VANYA

You know your father.

KITTY

I do?

VANYA

Your adopted father is your biological father.

KITTY

But…

VANYA

It's true.

KITTY

No it's not, he would've told me.

VANYA

He has secrets, secrets from you, from your Mum. Secrets which need to be kept.

KITTY

So why are you telling me?

VANYA

Because it's time.

KITTY

Time for what?

VANYA

Time you understood who you are.

KITTY

Who made you my guardian Angel?

VANYA

Less of the sarcasm.

KITTY

Look no offence, you seem like a... Nice guy, a bit creepy but okay. I'm just not sure what all this is about and, look, I have to get back to school. So, if you could find a new person to stalk, I'd appreciate it.

VANYA

My name is Vanya, I'm your uncle. My sister is your mother, your birth mother. She asked me to watch over you.

KITTY

Is she dead?

VANYA laughs.

VANYA

Quite the opposite.

KITTY stands and as she cuts her hand on the bench.

VANYA

You don't feel that do you? It's okay, I don't feel pain either.

KITTY licks the blood from her hand.

VANYA

Satisfying, isn't it?

KITTY

Who am I? Why am I different?

VANYA

Because you're a dhampir.

KITTY

A what?

VANYA

Vayda, you are the daughter of Meredith the head vampire.

KITTY laughs.

KITTY

Okay. A vampire! That's funny.

KITTY gets up to leave, turns and begins to walk away.

VANYA

Not a vampire as such. A dhampir; half vampire, half human.

KITTY stops and turns back to look at VANYA.

VANYA

Those pills your father gives you are suppressants.

KITTY

I'm epileptic.

VANYA

You're not. They supress your urges to kill. You don't remember ever seeing a doctor, do you?

KITTY shakes her head.

VANYA

That's because you don't get ill or feel pain. Vayda…

KITTY

Kitty.

VANYA

Kitty, you're immortal.

FADE OUT.

THE OTHER HALF OF ME

EXT. GRAVEYARD - DAY

 LENNY

She had her whole life ahead of her. It's so unfair, why her?

 MO

She loved life more than anyone I know.

 LENNY

Whenever she entered a room, she brought happiness with her. Even if we were having a bad day, she would have us laughing so hard by the end of it.

 MO

We'd forget our troubles.

 LENNY

It makes no sense. Why would God choose her?

 MO

It has nothing to do with God, Lenny. She made the choice to get into that car.

LENNY

I don't think I will ever be able to erase that night. I told her not to get in.

LENNY kneels at the grave side.

LENNY

I told you not to get in. Why did you have to get in? Why did you leave us?

MO

Len, it's not your fault. You've got to let it go. You've got to let her go. Come here.

MO holds LENNY.

LENNY

I can't. I can't face life without her, Mo.

MO

I'm here, we can get through this together. That's what she would want. She wouldn't want us to be sad. Mum needs us to be strong.

LENNY

She was my twin, Mo, the other half of me. I feel like part of me is missing. I miss her so much.

 MO

 Me too.

 FADE OUT.

CYBER CONSEQUENCE

INT. SCHOOL BATHROOM - DAY

MEL

You just want to blame me all the time, but you're involved too.

DAN

You started it, Mel, I just went along with it.

MEL

You wanted to scare her too.

DAN

You went too far and now look what's happened. She's in hospital, Mel. This is serious.

MEL

Do you think I don't know that? I've thought about nothing else.

DAN

If they look on her phone they'll see your messages.

MEL

Our messages.

DAN

They came from your phone.

MEL

You were with me; you were part of it, Dan. You're not letting me take the blame. I thought you were my friend.

DAN

And she thought you were her friend.

MEL

It was just a laugh. It was just for a laugh.

DAN

It's not funny now, Mel. She's fighting for her life. What if she dies? Or what if she lives and tells her mum what we did.

MEL

So, you admit you're part of this now.

DAN

I didn't want to scare her this much. It's not funny it went too far.

MEL

I know, do you think I don't know that, Dan. I know okay.

DAN

We need to tell Mr Davison what we did. I can't stand this.

MEL

Get a grip, Dan. She will be okay, and we can apologise to her. If we grass ourselves up, we will get excluded or worse. Everyone will hate us.

DAN

I don't think we should hang out anymore.

MEL

Wait, what?

DAN

I think we need time out from each other. My mum says you're a bad influence on me. Maybe she's right. I'm not getting in trouble for this. This was all your idea, and I don't want to be part of it.

MEL

But you are part of it. I'm not taking the blame. We did this together! And when did you ever care what your mum thinks? You said you didn't like her. It was you that wanted to get back at her after the whole homework scam thing. I only sent her a few messages; it's not like I hurt her.

DAN goes to leave.

MEL

Where are you going? Get back here! What kind of friend are you?

DAN

Maybe you should be asking yourself the same thing.

 FADE OUT.

A BIRTHDAY SURPRISE

INT. HALLWAY - DAY

There's a knock at the door. ALI goes to answer. BETSY is standing, grinning, with a present in her hand.

ALI

Hey!

BETSY

Hey, happy birthday!

ALI

Aww thanks.

BETSY

Shame you have to go to school.

ALI

Tell me about it. Tried to get my Mum to let me stay off but she's having none of it.

BETSY

At least you get to hang out with me.

ALI

Yeah. Hey, why don't we skip school? We could go to the beach.

BETSY

I can't. I'm already in trouble. You know, the whole Daz Jones thing.

ALI

Oh yeah. Look don't worry about all that. In a few weeks it'll be old news.

BETSY

I guess. Anyway, todays a celebration. Are you ready?

ALI

For what?

BETSY

This.

BETSY hands over the gift.

FADE OUT.

THE BREAK-UP

EXT. PARK - DAY.

JESSIE

You wanted to meet me? Why here.

ELI

It's quiet.

JESSIE

You wanted us to be alone.

ELI

Kind of.

JESSIE

That's sweet.

ELI

Well I wanted to have your full attention, I think we need to talk?

JESSIE

What do you mean?

There is an awkward silence.

JESSIE

You're breaking up with me.

ELI

I think it's for the best.

JESSIE

The best? Best for you?

ELI

Best for us both, you can see your friends more.

JESSIE

Gee thanks. I think you mean you can see yours.

ELI

I just feel a bit, you know... trapped.

JESSIE

Trapped! I'm not trapping you, you're free to see your mates, but you can see me too, or I could go out with you and your friends.

ELI

I don't think that would work; they're not tied down.

JESSIE

Tied down? Are you kidding me?

ELI

Sorry wrong choice of words. They're not in relationships.

JESSIE

Well they're missing out. Aren't they? Aren't they?

ELI

Not really, that's kind of the point I'm making.

JESSIE

How can you be so heartless after all this time?

ELI

That's a bit of an exaggeration.

JESSIE

But we've been going out for ages!

ELI

It's been a week.

JESSIE

You've clearly got commitment issues.

ELI

I'm ten! (*Note: can change to older*)

FADE OUT.

SANTA CAN ONLY BE RED

INT. CLASSROOM - DAY

MELISSA is drawing a picture of Santa. She begins to get frustrated as she searches for her missing red crayon.

MELISSA

Right, everyone! Stop right there. One of you has stolen my red crayon.

MISS MEADON

Calm down, Melissa. I don't think anyone will have deliberately taken your crayon. We share in this class.

MELISSA

But how can I finish my picture of Santa without a red crayon? Santa can only be red.

MISS MEADON

Now, has anyone got a red crayon that Melissa can borrow?

MELISSA

I want my red crayon. I bet it was Richard Miss. He's smiling.

RICHARD

It wasn't me, Miss.

MISS MEADON

Now you can't go accusing people without good reason.

MELISSA

Look at his picture. It's exactly the same as mine.

RICHARD

I did mine first, Miss.

MELISSA

Did not. You're a copycat, Richard Mathews. Look at him smiling.

MISS MEADON

Now, Melissa, smiling is not a crime, is it?

MELISSA

You're always on his side Miss.

MISS MEADON

Now, that is enough, Melissa.

MELISSA huffs and returns to her picture. Using every colour she has.

MISS MEADON

What a lovely picture of Joseph and his coat of many colours, Melissa.

MELISSA

Joseph. That's right Miss. That's exactly what I was going for.

 FADE OUT.

THE LAST GOODBYE

INT. VETS - DAY

COREY is stroking his TESSIE as the vet is preparing to put her to sleep.

COREY

I'm here, Tessie. Don't be scared.

VET

Tessie is so brave.

COREY

She is the bravest.

VET

It's time, Corey.

COREY

No! I'm not ready.

MUM

Come on, sweetheart. You need to say goodbye.

COREY

I can't.

COREY begins to cry.

 COREY

Don't do this. You can save her.
That's what vets do. Please.

 VET

She is in pain, Corey. It isn't fair
on her.

 MUM

She has had a good life, Corey, and
you have been the best owner.

 COREY

But she's my best friend.

COREY sobs harder.

 COREY

I'll miss you. Tessie. I promise
I'll think about you every day.
You've been the bestest friend a kid
could have.

TESSIE whimpers.

 COREY

You see. She wants to go home with
me.

 MUM

We need to leave now, Corey. Let the
vet do her job.

COREY wipes his tears.

COREY

Bye, Tess. Don't be scared, I love you.

FADE OUT.

THE WOODS

EXT. THE EDGE OF A WOODED AREA - DAY

MICHAEL is persuading his sister to go for an adventure in the wood. He is clearly the dominant sibling.

MICHAEL

Let's go!

JESS

Where are we going, Mike?

MICHAEL

I've told you we're going to the woods.

JESS

Can't we go somewhere else?

MICHAEL

Are you scared?

JESS

No... I just get bored listening to your stupid

ghost stories.

MICHAEL

Do you want to hear one now?

JESS

No!

MICHAEL

They're true you know, Dad says.

JESS

I don't want to go, Michael. Mum said we had to be

home by six.

MICHAEL

You're such a scaredy cat! Look I brought Dad's camera, if we can get a picture of the ghost, we'll be famous!

JESS

I don't want to be famous; I just want my tea.

MICHAEL

What's that?

JESS

What?

MICHAEL

That smoke coming from that house? It's meant to be empty!

JESS

Mikey, we have to go home.

MICHAEL walks on towards the house.

 JESS

Mikey, stop. Where are you going?

 MICHAEL

Come on, Jess, keep up, we haven't got all day!

 JESS

Michael!

 MICHEAL

Jess!

 JESS

Argh! You are going to get us in so much trouble.

JESS reluctantly follows. They approach the big wooden door of the abandoned house.

 FADE OUT.

HIDING

EXT. PLAYGROUND - DAY

BELLE is hiding at the top of a playground climbing frame which is enclosed at the peak of a slide. An older boy TIM makes his way to the top.

TIM

Belle. Belle, are you in here? Oh hey, are you okay?

Miss Dobson is looking for you.

BELLE

I'm not coming out.

TIM

Everyone is worried.

BELLE

No, they're not. They don't care about me.

TIM

You're not in trouble. Miss just wants to know you're safe.

BELLE

She's just worried that she'll get in trouble. Where's Chantelle?

TIM

Miss Dobson rang her mum. She's gone home.

BELLE

Great, so now her mum will hate me too.

TIM

Chantelle is a bully. Everyone knows it.

BELLE

But I hit her. My mum's going to hate me too.

TIM

She deserved it.

BELLE

No, she didn't. My mum says violence never pays. I don't know why I did it. I lost it, couldn't take any more. Now everyone will hate me, more than they already do.

TIM

Nobody hates you.

BELLE

Chantelle does.

TIM

Chantelle hates herself. She's jealous of you. Her life is so miserable that she feels the need to make others sad, just to make herself feel better.

BELLE

Really?

TIM

Really.

BELLE

She put worms in my hair.

TIM

I know and Miss Dobson knows that.

BELLE

I'm not coming down.

TIM

Okay. Well, I'm not either. I'll sit here with you.

BELLE

Why are you being nice to me?

TIM

Because I know how you feel.

BELLE

But you're one of the popular kids. Everyone likes you.

TIM

At school maybe.

BELLE

What do you mean?

TIM

Can you keep a secret?

BELLE nods.

TIM

My dad he…

TIM stops talking, he is struggling to get his words out.

BELLE

Did he put worms in your hair?

TIM smiles.

TIM

Not exactly.

They sit silently for a few moments.

BELLE

It's okay, Tim. You can stay here with me. I'll sit with you as long as you like.

FADE OUT.

RED FLAG

INT. BEDROOM - EVENING

NOOR is sitting on the bed with ALLY.

 ALLY

Stop.

 NOOR

Stop what?

 ALLY

Just…

 NOOR

Telling you the truth?

 ALLY

I'm not talking about this.

 NOOR

Why? Because you know I'm right.

 ALLY

What would you know?

 NOOR

I know what I saw.

ALLY

And I know you like to sabotage every situation.

You don't want me to be happy. You like me being the victim, so you can save me. Well, I don't need saving, Noor. I know you think I brought this on myself.

NOOR

I know what happened wasn't anything to do with you. It isn't your fault, but he isn't treating you right, Al.

ALLY

I didn't ask for your opinion. You don't know him like I do.

NOOR

I don't need your permission to have an opinion. He's a walking red flag!

ALLY

Shut up, Noor! It's none of your business!

NOOR

Calm down. You're being dramatic.

ALLY

Who do you think you are?

NOOR

I was trying to help.

ALLY

Well don't. I don't need your help.

NOOR

Don't you?

ALLY

No!

NOOR

Fine. If you want to end up without a single friend, go right ahead. Push me away, like you have everyone else.

ALLY

I don't need you constantly interfering. You always think I need protecting. I'm not as fragile as you think.

NOOR

Fine. I am so done with you.

NOOR starts walking out.

ALLY

Noor. Wait.

NOOR turns to face her.

NOOR

Wait? For what, Ally?

ALLY

I'm sorry. I just liked him. You're always trying to save me. It makes things worse.

NOOR

Why is it so bad that I want to protect the closest friend I've ever had?

ALLY

It's not. I'm just upset that's all.

NOOR

You deserve better. That's all I'm trying to say. You should know the truth about him. Stop the denial, Ally, You should accept it.

ALLY

I know. At least my head does, try telling my heart.

NOOR

I get it, I really do. I just hate seeing you so miserable.

ALLY

I am sorry. I know you care; I just need to fight my own battles.

						FADE OUT.

INVASION

INT. DERELICT BUILDING - DAY

ANT, ISLA, CHRIS & CONOR hide in an empty derelict house after an alien invasion has demolished most of the town.

ANT

Stay down.

ISLA

I can't breathe.

ANT

Do you want to live?

CONOR

Leave her alone.

ANT

Do you want to live?!

ISLA

Yes.

ANT

Then stay down. If they see you, we are all dead.

CHRIS

I think I can make a run for it.

ANT

No.

CHRIS

Who put you in charge?

ILSA

I can't breathe.

CONOR

You're okay. Slow breaths. Come here. Look at me. Let's breathe together.

ANT

It's a good job I am; you'd have us all run out there. It's not safe.

ILSA

I want my mum. Will she be okay?

CONOR

Of course. She's the bravest person I know.

CHRIS

And your leadership is telling us to hide. Then what? We can't hide forever.

CONOR

Will you two knock it off. We are all on the same side and you're scaring Isla. Wait, did you hear that?

CHRIS

What was that?

ILSA

I want my mum.

CONOR

Remember, slow breaths.

ANT

I think they're in the building.

CHRIS

Now can we run?

CONOR

The ventilation shaft.

CHRIS

What about it?

CONOR

I think that's where the noise came from.

ANT

They must be in the building. Let's make a run for the basement.

ILSA

I can't breathe. I can't…

CHRIS

That's the worst idea. There's no escape route from there.

ILSA

Look.

A long arm with two clawed fingers reaches out from the shaft.

Fear can be seen in the eyes of all four of them.

 FADE OUT.

THE PROJECTOR

INT. ATTIC - EVENING

Two children have found an old projector in an unoccupied house. They return later that day with some slides they've found in the hope of getting it working.

TJ

You're late.

TESS

So.

TJ

So, you said you'd be here on time. This isn't going to work if you mess me around.

TESS

It's a stupid idea anyway.

TJ

Really? Well, take a look at this.

TJ switches on the old projector.

TESS

You got it working!

TJ

Did you expect anything less. I'm a genius!

TESS

You're a dork.

TJ

I told you I could do it, you need more faith.

TESS

So, what now?

TJ

We check out those slides you found.

They set the machine up and project onto the wall.

TESS

These look really old. Look at what he's wearing.

TJ

His eyes seem to follow you around the room.

TESS

Why are all old pictures so spooky?

TJ

You're such a wuss.

TESS

Get lost, TJ.

TJ

Wait. Look closer, you see that?

TESS

What?

TJ

That. It looks like a figure in the background.

TESS

You're just trying to freak me out.

TJ

Look, Tess. There, like a streak of light, do you see the face, can you make it out?

TESS

Is this a set up? One of your crazy games to scare me?

TJ

How could I set it up, you had the slides?

TESS

TJ, look at that frame on the wall. Not that wall, the one in the picture. I recognise it.

TJ

It does look a bit familiar.

The man in the picture moves. They both jump.

TJ

Oh my… Tess did you see that?

TESS

I saw.

TJ

He moved. Pictures can't move. He moved, Tess he moved.

TESS

Okay, okay I know.

TJ

He moved!

TESS

I know I saw it too. Turn it off. Quick turn it off.

TJ

It won't turn off. How do I turn it off?

TESS

TJ, don't turn around.

TJ

Why?

TESS

That figure. It's not in the picture anymore.

 FADE OUT.

SPOOKED

EXT. WOODS - NIGHT

It's dark and RAYA and KRIS are in the woods. KRIS is beginning to get spooked.

KRIS

Raya.

RAYA

What?

KRIS

What was that?

RAYA

Will you pack it in?

KRIS

I heard something, there's something here.

RAYA

Probably the boogie man, get a grip.

KRIS

Don't move.

RAYA

Shut up, Kris.

A rustle is heard.

 KRIS

What the hell was that?

 RAYA

Don't turn around. There's something behind you.

A figure can be seen. Behind KRIS. RAYA's eyes widen with fear.

RAYA walks backwards into the tree, she leans on it and clutches it. Hands come out from the tree and pin her to it. She screams. Close up of her mouth.

 FADE OUT.

ALSO AVAILABLE FROM SALAMANDER STREET

The Ultimate Drama Pot Collection by Joanne Watkinson (paperback)
ISBN: 9781913630645
£14.99

A book packed with one hundred monologues, aimed at young performers from pre teens to young adults.

The book has been written by drama teacher Joanne Watkinson who has over 20 years' experience which includes heading up a performing arts faculty in a secondary school, GCSE and A-Level examining and most currently residing as the principal of a successful theatre school. She also has her work published in the 2019 LAMDA Acting Anthology and has several published plays.

The original monologues and scenes can be used for class work, festivals and exams. The monologues have guidance on age suitability, and there is a good mix of male and female characters, with some written as non-gender specific in order to give the performer a wider selection of pieces to choose from.

This collection of creative material would be a great asset to any drama teacher's resources and be of benefit to primary and secondary schools as well as youth groups, and those preparing for auditions.

'My students and I absolutely LOVE this monologue book! For my latest exams I had students perform 'I'm Not Scared' and 'The Loft' for their own choice monologues! And, 'I'm Not Ready' and 'It's Here Somewhere' as their anthology choices! These are HUGE hits.'

Dannika Dudfield, LAMDA Teacher

ALSO AVAILABLE FROM SALAMANDER STREET

Ultimate Drama Activities for the Classroom
by Joanne Watkinson (paperback)
ISBN: 9781914228131
£14.99

Drama Teacher's Best Friend

Packed full of games, activities and exercises, Ultimate Drama Activities for the Classroom is designed to be a drama teacher's best friend. Written by a drama teacher with over twenty years' experience which includes heading up a performing arts faculty in a secondary school, GCSE and A-Level examining and presiding as the principal of a successful theatre school, as well as being a published playwright and having her work featured in the 2019 LAMDA Acting Anthology.

As well as featuring drama games to use in the classroom, this book contains thorough instructions, valuable advice and useful activities to use in the teaching of improvisation and devising for small and large groups and working with script.

- Warm Up Games
- Improvisation and Devising
- Improvisation for Larger Groups
- Working with the Script

'What an absolute gem of a book! Yet again, Joanne has saved us drama teachers endless prep work by offering this excellent, handy, reliable and extremely helpful "go to" resource!'

Dave King, Drama Teacher and LAMDA Tutor

ALSO AVAILABLE FROM SALAMANDER STREET

All Salamander Street plays can be bought in bulk at a discount for performance or study. Contact info@salamanderstreet.com to enquire about performance licences.

BALISONG by Jennifer Adam

ISBN: 9781914228377

Balisong is a play written for schools as part of the No Knives Better Lives Programme promoting positive and active citizenship among young people.

STORM LANTERN by Duncan Kidd

ISBN: 9781738429370

Caught by the Nazis distributing forbidden leaflets, Sophie Scholl is facing execution. Only one route remains: confession and betrayal of everything she stood for… but will she take it? What would you be willing to die for?

A Play, A Pie and A Pint Volume Two

ISBN: 9781068696237

8 plays from Òran Mór, celebrating 20 years of Glasgow's lunchtime theatre phenomenon, including critically acclaimed plays and favourites as voted by the public and members of the theatre company.

MASKING by Nina Lemon

ISBN: 9781738429318

Nina Lemon's insightful play sensitively explores the challenges faced by a group of school kids as they cope with a high-stakes school system in a world that's piling on the pressure.

COWBOYS AND LESBIANS by Billie Esplen

ISBN: 9781914228902

When repressed British schoolfriends Nina and Noa write a parody American romance, the colourful, familiar characters come to life and show them that they might have a story of their own to tell.

Salamander Street